PHANTOM

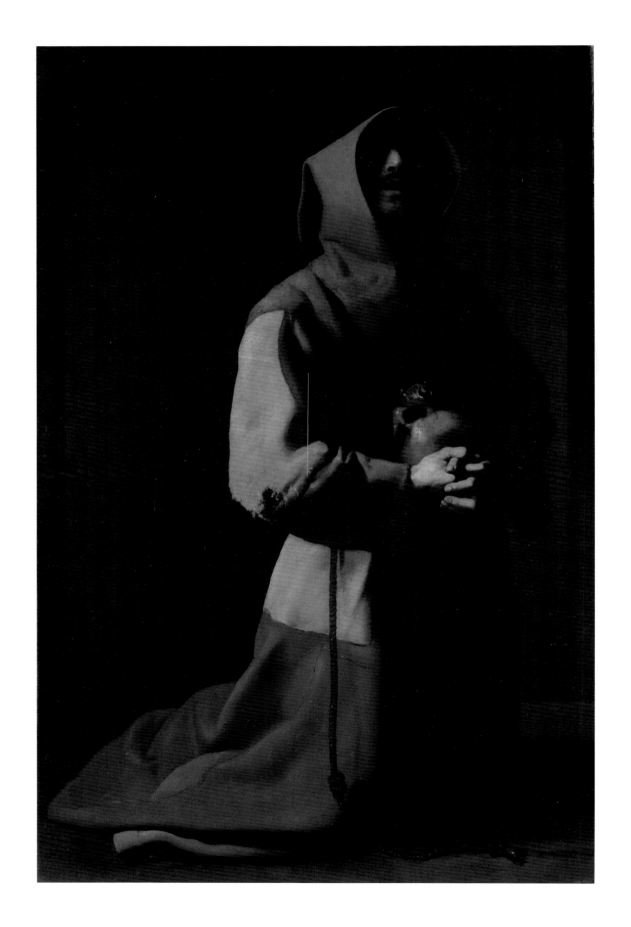

COLIN WIGGINS AND DON PATERSON

ALISON WATT
PHANTOM

THE NATIONAL GALLERY COMPANY · LONDON

Distributed by Yale University Press

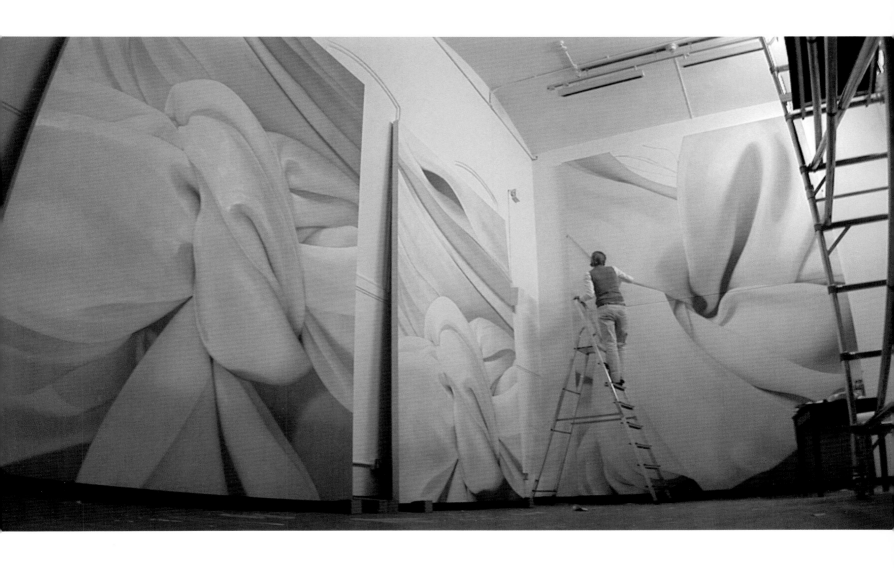

Above · Alison Watt working in her studio,
The National Gallery, London
Film still, 2006

Illustrated on page 2
Francisco de Zurbarán (1598–1664)
Saint Francis in Meditation, 1635–9
Oil on canvas, 152 x 99 cm
The National Gallery, London [NG 230]

DIRECTOR'S FOREWORD

In 2004, Alison Watt's monumental and mysterious painting, *Still*, was installed in the Memorial Chapel of Old St Paul's, Edinburgh. It was an immediate success, earning widespread public acclaim. With its gently suggestive folds of white fabric it is a painting that connects deeply with the long tradition of drapery in art that is so beautifully represented in the National Gallery.

Shortly afterwards, Alison accepted our invitation to become the National Gallery's seventh Associate Artist. In early 2006 she moved into the studio here and started to make new work in response to this great collection – one for which she has always expressed a fascination and affection. One of her great loves is Ingres's portrait of *Madame Moitessier*, resplendent in her voluminous dress, but as Alison worked here, Zurbarán's *Saint Francis in Meditation* became her central focus and she asked for it to be included as a prelude to her exhibition. We are happy to oblige. It is fair to say that this painting sent Alison in a direction she was not expecting. We thank her not only for her beautiful work but also for sharing her responses to Zurbarán's masterpiece, among other works in this collection, and for encouraging us to see it as a source for creativity, as a springboard for new art that takes its cue from the past but is undeniably contemporary. Alison's seductive work shows how the National Gallery is not simply a repository of old paintings but a living collection that continues to inspire and amaze.

Thanks are due to the Rootstein Hopkins Foundation for their generous support and encouragement of the Gallery's Associate Artist scheme. Thanks also to the Bank of Scotland Private Banking, for supporting this exhibition catalogue.

Finally, I must add that it has been a great pleasure to have Alison working here. The paintings she has produced have subtly redefined the way we look at the collection.

Martin Wyld
Acting Director, The National Gallery
January 2008

Bank of Scotland Private Banking is delighted to sponsor this exhibition catalogue. It is particularly pleasing to support a home-grown talent, and one who has studied at the prestigious Glasgow School of Art and exhibited at the Scottish National Gallery of Modern Art in Edinburgh.

Bank of Scotland Private Banking believe in looking at things differently in order to support creativity and entrepreneurship and this is evident in Alison's approach to her painting. Bank of Scotland is indeed delighted to have secured one of Alison's artworks which will hang in our Head Office at the Mound in Edinburgh.

Bank of Scotland is one of the biggest corporate supporters of the arts in Scotland and during 2007 the Bank sponsored the major Andy Warhol exhibition at the National Galleries of Scotland. In 2008, we intend to support other innovative projects. The Bank's award-winning arts sponsorship programme includes the Edinburgh International Festival, Scottish Opera and Scottish Ballet.

We believe that sponsorship is about partnership, whether in the business or arts arena and we applaud the vision of the National Gallery in acting as a resource and residency for artists at all stages of their careers, ensuring the best in art is brought to a broader audience.

Bank of Scotland Private Banking share the values of the Rootstein Hopkins Foundation who generously support the Associate Artist Scheme securing its future at the National Gallery.

We congratulate the National Gallery on mounting this inspirational exhibition.

Willie Raeburn
Head of Bank of Scotland Private Banking

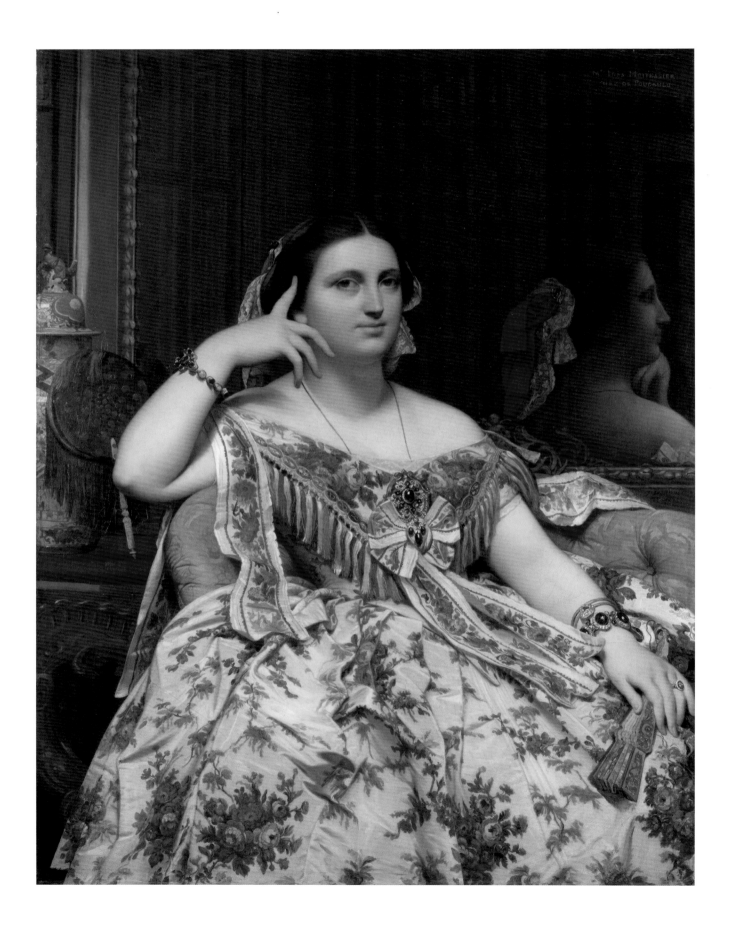

SOMETHING UNSEEN

COLIN WIGGINS

Alison Watt was first taken to the National Gallery as a child. Her father James Watt was a painter and teacher and so the idea of making and looking at pictures had been one that she regarded as a perfectly normal and natural activity. Of that first trip, she recalls her first encounter with Ingres's portrait of *Madame Moitessier* [fig. 1].

'I was about seven or eight years old and my parents brought me here for my first visit. I must have seen dozens of paintings on that particular day but the only one I can remember is *Madame Moitessier*. I remember being introduced to the painting. I remember my father saying "This is *Madame Moitessier*", so there is a very marked point at the beginning of my relationship with it.'

Her fascination with the painting can justifiably be thought of as obsessive. Indeed, one of the reasons for inviting Watt to be the National Gallery Associate Artist was her admitted fixation with this particular portrait:

'Whenever I look at *Madame Moitessier* I find myself being drawn away from her face, which is looking at me. My eye always drops to the fabric of the dress and I find myself becoming lost in that area of the painting. The longer you look at it, the stranger it becomes because your eye begins to play tricks on you. The fabric moves in and out of focus, certain areas

loom forward, other areas recede. There's a brilliant description of this painting by the American painter, Kenneth Noland. He says that *Madame Moitessier* burns off the wall at 50 paces. I love this description because I feel it describes my own experience of the picture.'

As the National Gallery's seventh Associate Artist, Watt was given the use of an on-site studio and access to the Gallery collection out of normal opening hours. On moving into the studio, Watt requested a large colour reproduction of *Madame Moitessier* for her wall, and was rather frustrated to learn that the painting itself was on loan in France for three months. While it was away, Watt began to form new connections with other National Gallery paintings – relationships that intensified during her time at the Gallery. Prolonged, continual looking was a key part of her time as Associate Artist and she viewed her out-of-hours access to the collection as an experience that became ever more important to her, if at times strange and unsettling.

In addition to *Madame Moitessier*, she asked for reproductions of several other works: Ingres's portrait of *Monsieur de Norvins* was one of these, along with Moroni's little *Portrait of a Man*, David's portrait of *Jacobus Blauw* and Zurbarán's *Saint Francis in Meditation* [p. 2]. These she placed around her studio. She

Fig.1 · Jean-Auguste-Dominique Ingres (1780–1867) *Madame Moitessier*, 1856 Oil on canvas, 120 x 92.1 cm The National Gallery, London [NG 4821]

13

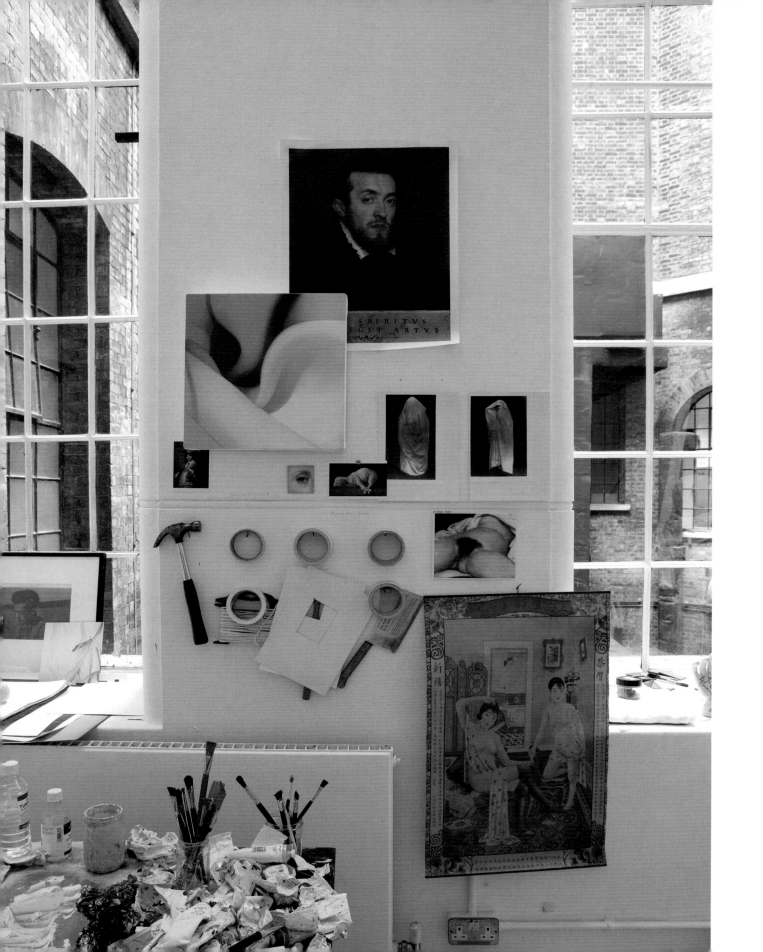

also compiled a collection of postcards and reproductions that she grouped together on one small area of the studio wall. Many artists seem to feel the need to invite their artistic predecessors into their studio in this way and Watt is no exception. For visitors, they can provide clues towards an understanding of the artist's thought processes. Looking at her postcard collection, it is not unexpected to find pictures there by artists such as Holbein, Ingres or Zurbarán. But the only twentieth century artists whose work appears on Alison Watt's postcard wall are perhaps surprising. Lucio Fontana and Dan Flavin are both artists who specialised in creating determinedly modern and minimalist works and their presence provides an interesting contrast to the Old Masters.

Watt made one further and noteworthy request for her studio, for a reproduction of a painting that is not in the National Gallery's collection, and has long intrigued her, Courbet's *L'Origine du Monde* [*The Origin of the World*] which she placed prominently on the wall [fig. 2]. Perhaps significantly, aside from *Madame Moitessier*, the images from the National Gallery's collection that Watt gathered for her studio walls were all portraits of men. *L'Origine du Monde* adds a forceful female counterpoint. Of all of these images however, it was to be Zurbarán's *Saint Francis in Meditation* which would soon rival *Madame Moitessier* for Watt's enduring scrutiny.

* * *

By the end of the 1990s Alison Watt had established her reputation as a painter of fabric. The depiction of fabric has been one of the defining characteristics of European art, although it is not often recognised as such. Usually drapery seems to be at the service of something else, either to indicate classical or historical subject matter or to denote wealth, class or status. As a pictorial device, tumbling and billowing fabric has enabled artists to convey movement and motion in a painting. But drapery *per se* has rarely been allowed to have its own identity. For several centuries the

academic study of the nude was seen as the root of all artistic excellence, with drapery only ever given a supporting role. Indeed, early on in her career Watt was producing pictures firmly within this tradition. Working extensively with life models and images of herself, the fabrics and draperies in her paintings originally had a more subordinate role.

Much of the work that Watt was making during her time at the Glasgow School of Art, and immediately after, had its origin in life painting. She developed a process of working from the nude model, often sitting or reclining on a *chaise longue* that was draped with a sheet. In *Sleeping Nude* of 1988 [fig. 3] the model's pearly pale skin is immediately arresting while the swathes of the fabric on which she rests are there to contrast with her form.

Some years later, it was during the making of such a painting that Watt made an unexpected observation that was to inform a new creative direction for her. After her model had completed a sitting and left for the day, Watt

Fig. 3 · Alison Watt (b. 1965)
Sleeping Nude, 1988
Oil on canvas, 91.5 x 122 cm
Private Collection

15

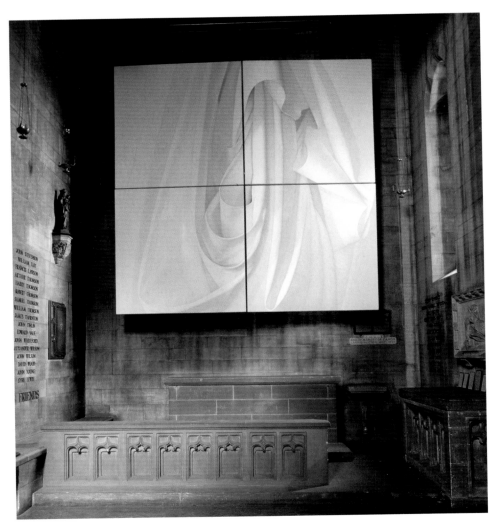

noticed that the sheet bore the imprint of the woman's body and had in effect became a palimpsest, loaded with memories of the previous painting sessions. Subsequently, the folds, shadows and patterns of the sheet itself, with their indications of the presence, and indeed absence, of the human figure gradually became of greater interest to the artist than the depiction of the actual model. During the 1990s, Watt produced paintings where the model and the fabric became separated until she finally began to make paintings showing fabric alone. Watt's first exhibition dedicated to solely her fabric paintings opened at Scottish National Gallery of Modern Art in 2000. At the time, she was the youngest artist to have been given a solo exhibition there.

This interest in fabric culminated in 2004,

when Watt undertook a prestigious public commission, *Still* [fig. 4], which was unveiled in Old St Paul's Church, Edinburgh. This monumental painting is made up of four canvases, each six feet square that almost, but not quite, join together. *Still* was made specially for the church's Memorial Chapel, dedicated to parishioners who perished during World War One. Of course, the meaning of a painting can often be affected by its surroundings. The purpose of the chapel is to encourage visitors towards the contemplation of loss and sacrifice. In this setting the cross shape made by the shadows in the narrow gap between the canvases takes on a Christian symbolism in such a way that would not happen if the painting were exhibited in a more neutral gallery space. Consequently the white fabric

becomes evocative of a burial shroud. The overwhelming sense of whiteness, with its traditional association of purity and specifically of the Virgin Mary, also conveys a powerful sense of a sacred presence that is inevitably informed by the context. Chameleon-like, Watt's painting takes on aspects of the environment in which it is displayed.

A readily acknowledged source for *Still* is Francisco de Zurbarán's *Saint Serapion* [fig. 5]. Zurbarán's treatment of the murdered saint's white robe both conceals and reveals: the explicit details of the saint's agonies are not shown, yet the turbulent tumbles of his habit suggest his suffering. Watt's fascination with this painting sheds considerable light on the meaning of her own picture. Both are created to provoke contemplation and use fabric in a way that is at once emphatically physical and yet also deeply spiritual. That the folds of *Still* become reminiscent of a religious habit take their cue from Zurbarán's picture. Although no human figure is represented, an invisible presence is hinted at, manifested in the gathers and shapes of the carefully arranged swathes of fabric. Within the confines of Old St Paul's, this is especially effective.

Alison Watt moved into the National Gallery studio in February 2006. As already noted, she surrounded herself with key visual influences, from the spiritual asceticism of Zurbarán to the material sensuousness of Ingres and the

Fig. 5 · Francisco de Zurbarán (1598–1664)
Saint Serapion, 1628
Oil on canvas, 120 x 103 cm
Wadsworth Atheneum
Museum of Art, Hartford,
Connecticut (CT)

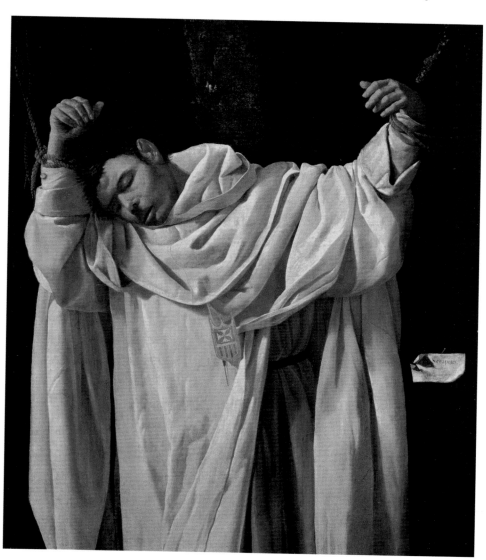

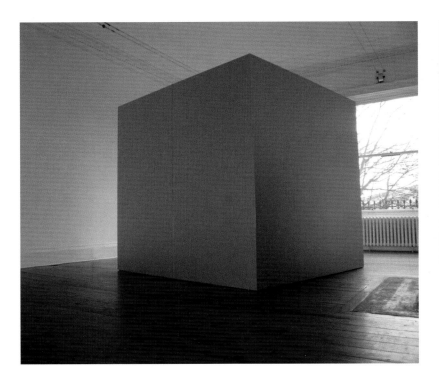

Figs. 6 and 7 · Alison Watt
(b. 1965), *Dark Light*, 2007
Installation at Ingleby Gallery,
Edinburgh, and detail of interior.
External dimensions 230 x 230
x 230 cm; internal panels, oil on
canvas, 200 x 200 cm

earthy reality of Courbet, and embarked on a series of powerful, large-scale paintings.

Watt's canvases in this exhibition appear at first to be overwhelmingly white but this sensation is arrived at with a surprisingly varied palette that includes white, Payne's grey, burnt sienna, cadmium red and yellow ochre. Before her spell at the National Gallery Watt had made a series of black pictures for an installation, *Dark Light*, in Edinburgh [figs. 6 and 7]. Now she chose to revert to working in a lighter key. The titles for her works are chosen during their creation, or shortly after. She prefers words with an ambiguity that allow spectators to find their own interpretations.

With hindsight, there is a distinct progression from painting to painting that was perhaps not so obvious while the works were being made. The first two, *Pulse* and *Echo* [cats. 1 and 2], have the common feature of a large knotted form and are clearly related to one another. These two compositions were partly generated from photographs of carefully arranged and lit swathes of fabric that Watt had taken after she had spent much time handling, manipulting and tying the fabric. It is not so

much the photographs themselves that are important, rather it is the experience of a prolonged handling of the material. Accordingly, the two paintings began with something real and tangible. The resultant work perhaps inevitably has a sense of weighty physicality that seems to push the folds of fabric into the spectator's space.

Pulse and *Echo* are the first large scale fabric paintings that Watt has made since *Still*, some two years earlier, and there is quite a contrast. Instead of the fragile delicacy of *Still*, there is an aggressive thrust to the newer pictures, slightly offset by the open folds at the top of the picture that suggest points of entry. In the later National Gallery paintings this notion becomes the dominant theme, but in these first two paintings it is the forceful and physical property of the knots that give the works their character.

It might be suggested, in contrast to Watt's other paintings with their soft folds and openings, that these two images are notably masculine. Indeed, Watt is open to the suggestion that there might be a link between two of the male portraits in the Gallery's collection,

Fig. 8 · Alison Watt's studio,
The National Gallery, London,
2007

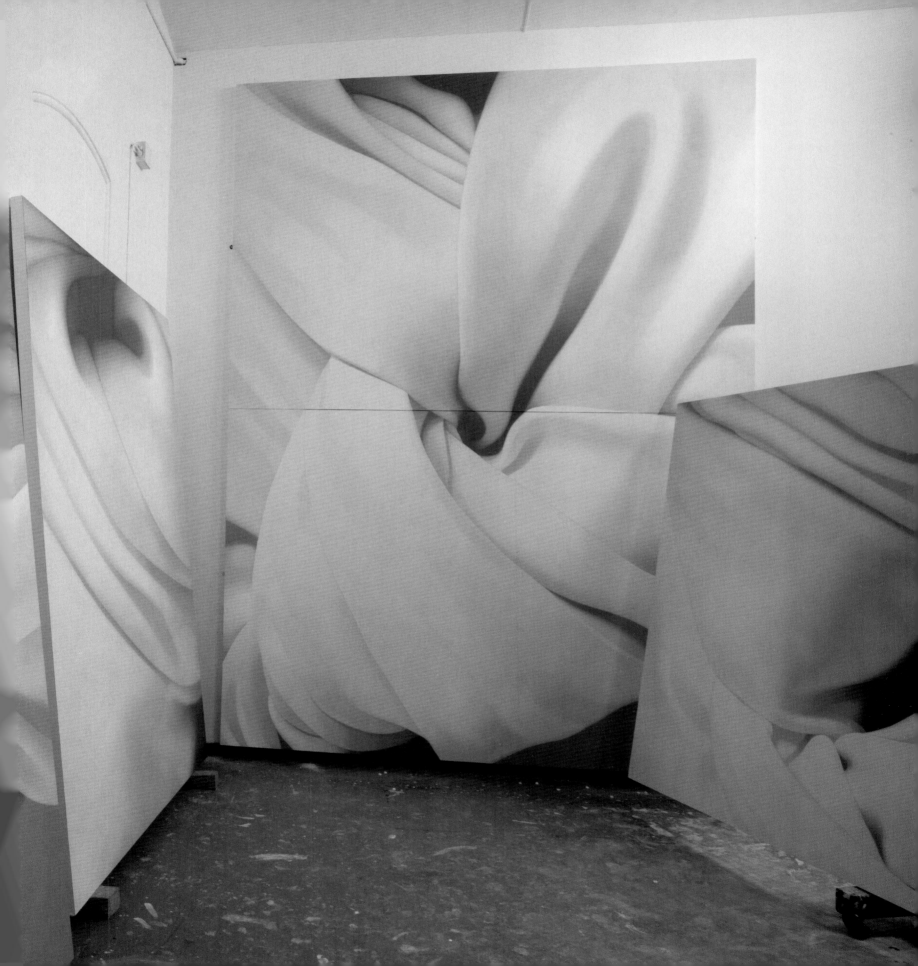

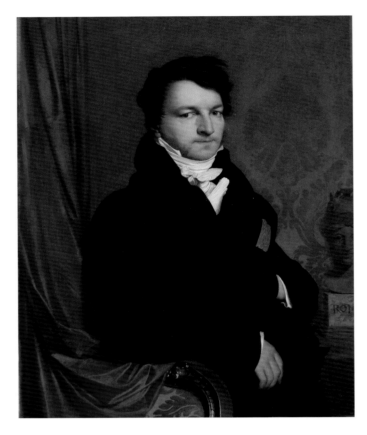

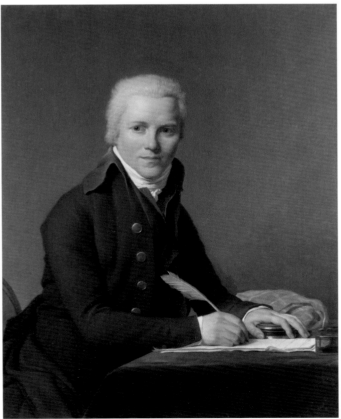

both of which she had on her studio wall. The portraits of *Monsieur de Norvins* and of *Jacobus Blauw* both show sitters with that ubiquitous item of male fashion from the romantic period, the white knotted cravat [figs. 9 and 10]. Speaking of *Jacobus Blauw*, she has said that she was 'fascinated with the arrangement of fabric around the neck and the shape that it was creating, and how the fabric seems to have an independent movement. It seems to swell and curve and snake around the neck in a way that seems to be quite separate from the person it clothes.'

Whatever masculine qualities might be discerned in these two paintings, they have completely disappeared in the subsequent work. In *Host* [cat. 3], the knot has gone and in its place is a very specific and definite hole, around which dramatic folds billow and swirl.

This picture is a distinct departure in many other ways, not least in terms of larger size. Furthermore, the composition of *Host* is now imaginary and from this moment on Watt abandoned the idea of using assemblages or photographs of fabric as part of her process, preferring instead to conjure up the images herself. Perhaps as a result of this new way of working, *Host* seems to be losing its connection with fabric, playing with abstraction. Indeed, the area of the painting at the bottom right has very little to do with conveying an idea of realisable drapery structures, and visitors to the studio often saw the painting as anything but fabric. *Host* has been variously described as being like a seashell, a human ear, dried and parched bones, or the petals of a flower. Such readings provoke comparison with the work of Georgia O'Keeffe, although Watt is adamant that there is no conscious influence. Nevertheless O'Keeffe's paintings, especially the large close-ups of flowers, hover on that same edge between figuration and abstraction that is occupied by Watt's fabric paintings. Also common to both artists is the difficulty that viewers have in resisting a sexual interpretation. O'Keeffe consistently

Fig. 9 · Jean-Auguste-Dominique Ingres (1780–1867) *Monsieur de Norvins*, 1811–12 Oil on canvas, 97.2 × 78.7 cm The National Gallery, London [NG 3291]

Fig. 10 · Jacques-Louis David (1748–1825), *Jacobus Blauw*, 1795 Oil on canvas, 92 × 73 cm The National Gallery, London [NG 6495]

denied that her paintings had a sexual content but Watt is quite happy for her pictures to be seen in such terms. And, given her bold display of Courbet's *L'Origine du Monde* [fig. 16] in her studio, it is impossible not to see her work as having a similar, if not quite so explicit, subject matter.

There are other departures apparent in *Host*. Watt's earlier fabric paintings, such as *Still*, all gently draw the eye inwards, into the folds and shapes that exist within the edges of the canvas. Yet now, although there is a very pronounced centre, there is the appearance of a dramatic movement away from it rather than into it, with four great shapes apparently rushing to the corners, like the sails of a windmill. This gives the painting an expansiveness, implying a continuation beyond the picture's edge. There is a tension between being drawn into the illusionistic point of entry and being flung out again by an opposing centrifugal energy.

Host is made on two landscape format canvases placed one on top of the other. However, as with *Still*, the join between the two parts of the picture unexpectedly plays an important pictorial role. While she was making the painting, Watt tried to ignore this join but nevertheless she became fascinated with its formal properties. Visually, it cuts horizontally through the very edge of what might be described as the painting's epicentre. Therefore the spectator is given both an illusionistic recession and a real one that has been created by the narrow gap that exists between the two canvases. This has an intriguing connection with Watt's interest in the work of Lucio Fontana and Dan Flavin.

Fontana and Flavin worked within extremely limited formats and they appeal to Watt because of the restraint and structural rigour of their work. Fontana's principle contribution to European modernism is the series of elegantly slashed canvases known as *Concetti Spaziale* [*Spatial Concepts*, see fig. 15]. By the simple device of a vertical slit cut into an otherwise untouched canvas, a gesture that is

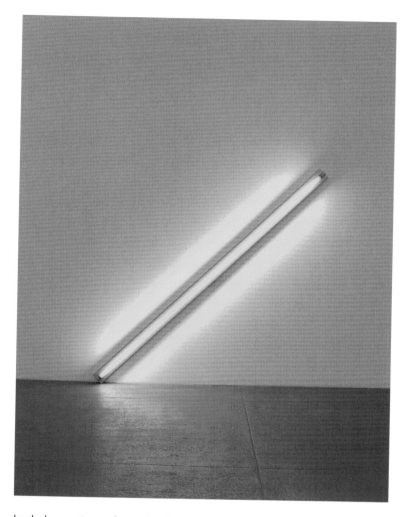

both destructive and creative draws attention to the physical and two-dimensional nature of the surface of a painting, while simultaneously activating the space that exists behind that surface. The viewer is confronted with a real space, dark with shadow – not an imaginary and illusionistic one. The tradition of looking through a canvas into an illusionistic pictorial space – where we might expect to see Ingres's and David's figures or Zurbarán's intense drama – is thereby paradoxically denied and confirmed.

The narrow join in *Still*, given its Christian environment, presents a possible symbolic reading. In *Host* however, the narrow space seems to exist purely on its own terms. Fontana's slashed canvases have themselves been subject to symbolic readings and when discussed alongside Watt's paintings, the

Fig. 11 · Dan Flavin (1933–1996)
*The diagonal of May 25, 1963
(to Constantin Brancusi)*, 1963
Yellow fluorescent light, 244 cm
Dia Art Foundation, New York

temptation to move into Freudian territory and to see them as female becomes pretty unavoidable, especially as she placed her Fontana postcard near to her reproduction of Courbet's *L'Origine du Monde*. But it is perhaps more helpful to see the link between Fontana's slashed works and Watt's adjoined canvases in terms of light and shadow, especially given Watt's admiration of Dan Flavin. She sees Flavin's

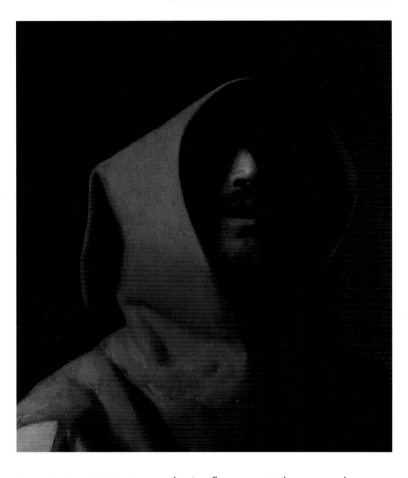

Fig. 12 · Francisco de Zurbarán (1598–1664), *Saint Francis in Meditation*, 1635–9 (detail)
Oil on canvas, 152 x 99 cm
The National Gallery, London
[NG 230]

glowing fluorescent tubes as a polar opposite of the dark recesses of Fontana's slashes, within which light is absent. Consequently, in Watt's eyes the two artists complement one another: Fontana works with shadow, Flavin works with light and Watt's interest in them as a pair can perhaps be seen as an aid to a deeper understanding of her own work, by tempering a physical, Courbet-inspired interpretation with something more numinous.

Aside from the postcards of work by Fontana and Flavin, there is one other curious group of images tacked to Watt's studio wall, this time the work of a photographer. Gaetan Gatian de Clerambault was a French psychiatrist who used photography as part of his research into the symptoms of hysteria. In 1915, after being badly wounded when serving in the French Army, he convalesced in Morocco. While there, he took hundreds of photographs of draped and veiled Moroccan women [fig. 13]. These mysterious photographs, often with the entire body covered, have a hypnotic power that borders on the fetishistic. One of the de Clerambault photographs on Watt's studio wall shows a woman completely wrapped in a heavy white fabric with only a tiny gap around her eyes to indicate that there might actually be somebody present. This little opening bears comparison with the points of entry that are such a feature of Watt's newest works. We cannot actually distinguish the woman's face but we know she is in there. Apparently straightforward and yet disturbingly ambiguous, de Clerambault's images are a photographic equivalent of the themes that so preoccupy Watt in her painting. The photographs share qualities with Zurbarán's *Saint Francis in Meditation* [fig. 12], which became one of Watt's most talismanic pictures during her time at the National Gallery. The hooded saint's features are obscured by deep shadow. We cannot see his eyes, which are suggested but not depicted.

Watt has attributed the genesis of *Host* to her intense observation of *Saint Francis*. As often as she could, she was spending much time alone with the painting, which was moved to the Conservation studio for a few days, to enable her to study it without its frame and under ideal lighting conditions:

'Zurbarán is a master of painting fabric. He paints it with such intensity that he seems to give the fabric a life of its own. Zurbarán's fabric is fabric you want to touch, fabric you want to smell, you want to listen to ... like a living mass. It is so sculptural, as if the folds have been carved rather than painted.'

It is easy to see how Watt, with her own

Fig. 13 · Photograph by Gaetan Gatian de Clerambault (1872–1934), early twentieth century.
Musée du quai Branly, Paris

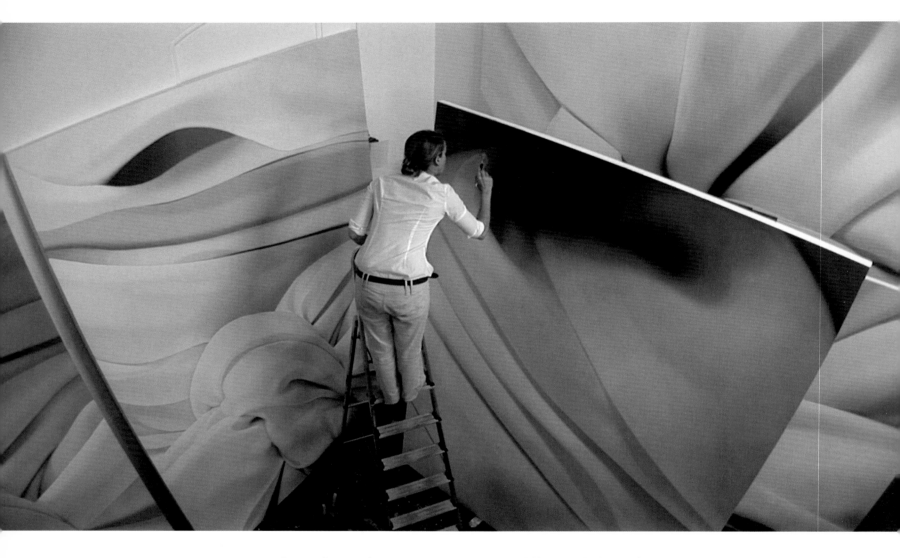

Fig. 14 · Alison Watt working
on *Vowel*, The National Gallery,
London
Film still, 2006

repertoire of material arranged into suggestive forms, should find herself drawn towards Zurbarán. The effect upon her own work of those sculptural folds can be seen clearly in the next three paintings, *Phantom, Vowel* and *Root* [cats. 4, 5 and 6]. These paintings share the feature of a darkly shadowed entrance that might also be understood as a place of exit. Whatever the preferred reading, these apertures become a line of demarcation between the visible and the invisible, a doorway between the real world and some other place, in a comparable sense to Fontana's *Concetti Spaziale* or de Clerambault's Moroccan robes.

Zurbarán's *Saint Serapion* had already had a profound impact on Watt when she was making *Still*. This is an overwhelmingly white

picture and likewise, the habit of *Saint Serapion* is also predominantly white. *Saint Francis in Meditation* though, is a much darker painting although it too has that same tension between the seen and the unseen. Watt's interest in it began slowly, as she started to notice that Zurbarán's picture was full of points of entry. There is the hooded cowl of the saint, his open mouth, the dark shadows created by the folds of the fabric and, perhaps most significantly, the empty hollows of the skull that he clasps. 'Every time I look at it and spend some time with it, I see something new in the picture. I suddenly realised that in the skull that he is holding, the shape of the eye socket was a shape that had appeared in one of my own very recent paintings. And so now, when I

look at my painting in the studio, I don't see fabric, I don't see cloth, I see bone because I relate it to the skull in *Saint Francis*.'

Phantom, even more so than *Host*, appears to shift from being a representation of fabric to take on another identity. From here on, it is no longer possible to define Alison Watt as being solely a painter of fabric. The possibility of different understandings increase exponentially. To compare her painting with the skull of Zurbarán's saint is only one interpretation because additionally, the format of *Phantom* is horizontal, suggesting a rocky and snow-covered landscape whose principal feature is a cave. Of course, the painting was most certainly started with the intention of making a painting of fabric, but as her time at the National Gallery gathered momentum, Watt seemed more and more interested in allowing the illusionistic representation of material to lose its focus. In *Phantom* the most significant part of the painting is no longer the material itself, but in the negative space. There is no telling what might be found in there. The title of the

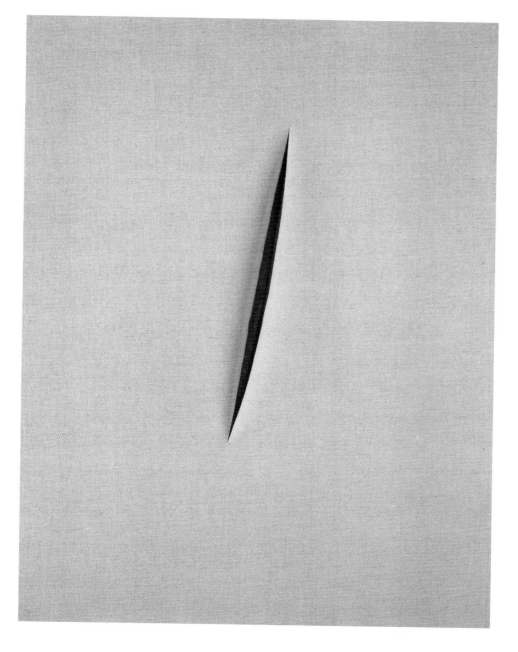

Fig. 15 · Lucio Fontana
(1899–1968)
Concetto spaziale 'Attesa', 1960
Oil on canvas, 93 x 73 cm
Tate, London [T00694]

painting tantalises and hints at something invisible, yet present. In conversation, Watt often mentions childhood memories of being wholly enveloped in her bedclothes and enjoying the feelings of security, comfort and warmth that are so important for any child. Accordingly, the illusionistic points of entry into her abstract swathes of luxuriant form can perhaps be seen as autobiographical metaphors of desire or the workings of unconscious memory.

The composition of *Root* is cropped from *Phantom* and focuses more tightly upon the idea of the aperture. *Root* is a square painting and consequently the landscape connotations are gone. Were it not for our knowledge of Watt's previous work it is debatable as to whether or not this painting could be recognised as being about fabric at all. Sculptural forms take precedence over softness and texture. Curved shapes dominate, which is a particular feature of all of Watt's National Gallery work. This is in marked contrast to the work she was making before, as exemplified by *Still*, where the pictures had more of a static geometrical underpinning and less apparent movement. In art historical terms, this progression in Watt's work can be seen as following the development from the balance and order of classicism to the drama and motion of the Baroque.

Vowel is indicative of how Watt's work made at the National Gallery has been moving away from the painting of matter towards something less definite. The idea of the title came to Watt after conversations with Don Paterson, who she had invited to contribute to this catalogue. Paterson is a poet whose work Watt has admired for a long time. He has always been fascinated with the nature of vowels and he prefers that when his work is published, the typefaces used have pronounced vowel shapes. The piece that he wrote engages with Zurbarán's *Saint Francis in Meditation* and it helped Watt to come to a closer understanding of why she is so mesmerised by it. The title of Watt's painting, *Vowel*, immediately encourages the viewer to see the gaping

horizontal entrance at the top of the picture as being some kind of mouth. Of course *Saint Francis* also has a mouth. The painting is silent but we can sense the saint's breath. We can even imagine him having some kind of voice, perhaps not enunciating any particular words, but simply being a voice. The aperture at the top of *Vowel* connects deeply with one of those many points of entry that so fascinate Watt in Zurbarán's painting: the open mouth of Saint Francis. Although placed at the very edge of her picture, this aperture is the true subject of the painting. The work is not about something tangible and physical, but about something empty, a void, a negative that then becomes the carrier of something unseen, a phantom presence that exists somewhere that is unseeable and therefore unpaintable.

All of Watt's paintings discussed so far are large and, if standing closely enough, they engulf the viewer's whole visual field. In contrast, *Eye* [cat. 7] is 30 cm square. It features one narrow upright opening that refers back to the little apertures at the top of her first two paintings, *Pulse* and *Echo*. In these two earlier paintings though, the little points of entrance are horizontal whereas in *Eye* it is pronouncedly vertical, a feature which also connects it to Lucio Fontana's upright slashes. In addition, this verticality of course, perhaps provocatively, relates it to Courbet's *L'Origine du Monde* [fig. 16].

To discuss the gently suggestive paintings of Alison Watt alongside Courbet's *L'Origine du Monde* is potentially awkward. With their gentle feminine creases and folds, and their very conspicuous points of entry, comparison with Courbet's challenging hymn to the female has the danger of over-emphasising any sexual symbolism that might be contained in Watt's work. However, she is assuredly mesmerised by Courbet's unambiguously realist painting: 'The Origin of the World is one of the most extraordinary paintings ever made. I think it's a picture that exists outside the time in which it was painted. If you look at a moving image, it has a beginning and an end, but when you

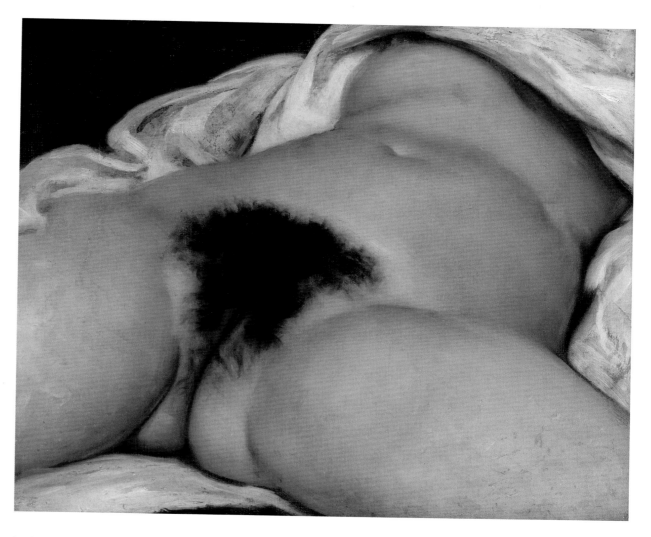

look at a painting like this, it just goes on and on … it defies description.'

It is perhaps surprising to find a heterosexual woman responding so passionately to a painting that was made for a private client who commissioned it to add to his collection of erotica. The original purpose of the work was to titillate male viewers and it was certainly not meant for female eyes. However, by adopting it as one of the signature images on the wall of her studio, Watt seems to be claiming it as positive statement of femininity as well as challenging the visitor to see her own paintings as coded responses to Courbet's subject. 'It's a very interesting piece to have on the wall because everyone who comes into the studio looks at it. It is fascinating to me to see who passes comment on it and who doesn't … some

people want to talk about it and some people don't and some look away but everyone who comes in looks at it because you can't take your eyes off it: it completely draws you in.'

Context is everything. Pinned to the wall in a male artist's studio, *L'Origine du Monde* could have a very different meaning to the one it assumes in Watt's studio where it is placed in her collection of 'point of entrance' images which includes religious work by Zurbarán, fetishistic photographs by de Clerambault and a modernist icon by Fontana. Yet there is more to Courbet's painting than is immediately apparent. As well as the obvious subject, this work is also a painting about fabric. Swathes of white material surround the model's body, flowing around her and revealing her. Like the habit of Saint Francis or the knotted cravats

Fig. 16 · Gustave Courbet
(1819–1877)
L'Origine du Monde, 1866
Oil on canvas, 46 x 55 cm
Musée d'Orsay, Paris
[RF 1995-10]

27

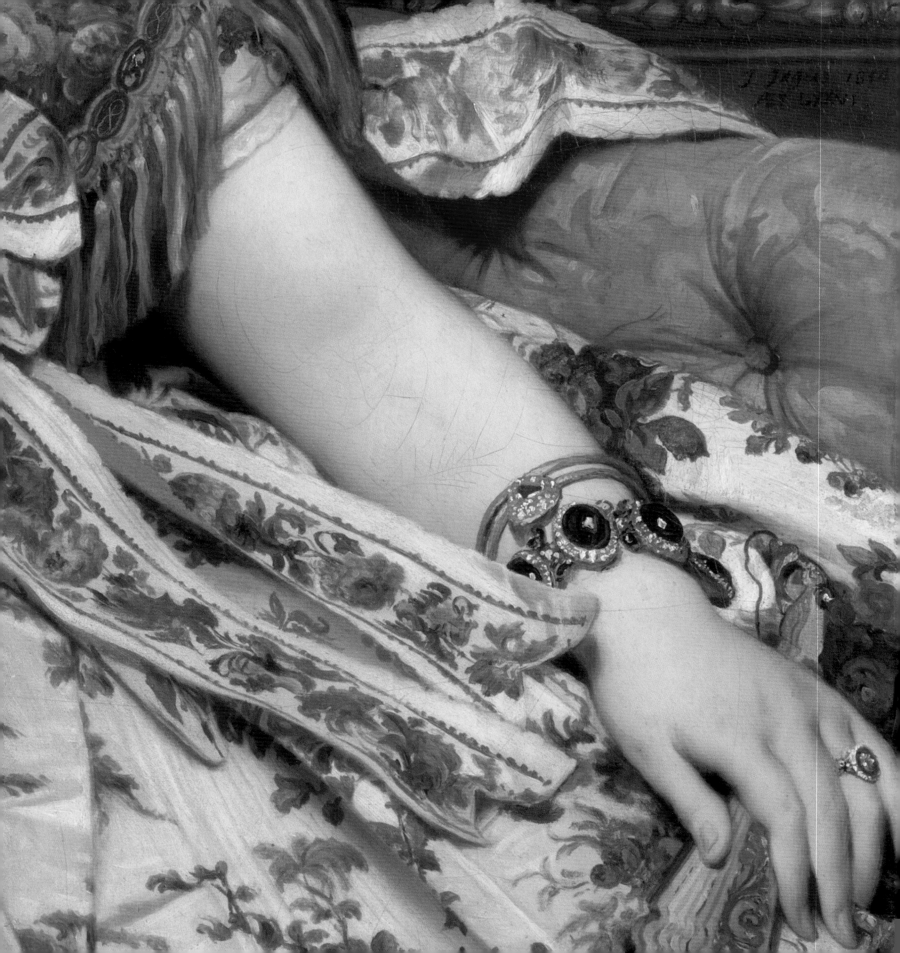

of Monsieur de Norvins and Jacobus Blauw, it seems to have a life of its own. And given Watt's long-standing fascination with the sumptuously clad Madame Moitessier, whose bizarre body shape is emphasised by her dress, to find her similarly gripped by the wrapped and yet unwrapped woman of *L'Origine du Monde* should not be a surprise.

Alison Watt began her time at the National Gallery with the optimistic thought that the deepening familiarity of day-to-day contact with *Madame Moitessier* would allow her to reach a greater understanding of it. She gradually learnt however that this was an impossible goal. In fact, the opposite had happened and the paintings in the National Gallery became more mysterious for her. The growing acceptance that it is ultimately impossible to understand a great work of art is perhaps the most defining characteristic of Alison Watt's time as Associate Artist at the National Gallery. And as her work progressed, she moved away from the physical certainties of the first two paintings, *Pulse* and *Echo*, whose origins were in real knots of fabric, and started to make paintings from her imagination, where the empty spaces became more important, loaded with hints of the unknowable and that connect with the mysteries concealed inside Zurbarán's great image of Saint Francis.

This recognition that the unknowable will always be of more interest than the knowable is reflected in some of her recent thoughts on *Madame Moitessier*:
'I think the most beautiful part of the painting, having known it for most of my life, is its darkest point. There is an exquisite shadow underneath *Madame Moitessier*'s left arm, surrounded on three sides by fabric and on one side by skin. That's the part of the painting I want to enter into and it is fascinating to me that the very point of the picture that I'm most drawn to is the point that's most concealed from me.'

Fig.17 · Jean-Auguste-Dominique Ingres (1780–1867)
Madame Moitessier, 1856 (detail)
Oil on canvas, 120 x 92.1 cm
The National Gallery, London [NG 4821]

PHANTOM

DON PATERSON

I.M. MICHAEL DONAGHY

I

The night's surveillance. Its heavy breathing
even in the day it hides behind.
Enough is enough, and there and then you crossed
your brilliant room and flung the curtains back
to catch the night pressed hard against the glass,
threw up the sash and looked it in the eye.
But it did not stare you out of your own mind
nor roll into the room like a black fog
but sat there at the sill's edge, patiently,
like a priest into whose hearing you confessed
every earthly thing that tortured you.
When you were done, it reached into the room
switching off the mirrors in their frames
and undeveloping your photographs;
it gently drew a knife across the threads
that tied your keepsakes to the things they kept;
it slipped into a thousand whispering books
and laid a black leaf next to every white;
it turned your desk-lamp off, then lower still.
Soon there was nothing in the silent dark
but one white cup, floating at shelf-height,
radiant and holy by omission.
The night bent down, and as a final kindness
placed it in your hands so you'd remember
to halt and stoop and drink when the time came
in that river whose name was now beyond you
as was, you noted with a smile, your own.

11

Zurbarán's *Saint Francis in Meditation*
is west-lit, kneeling, hooded, tight in his frame,
his fingers interlaced both in petition
and to clasp the old skull to his breast.
This he is at pains to hold along
the knit-line of the parietal bone
the better, I would say, to feel the teeth
of the upper jaw gnaw into his sternum.
His face is tilted upwards, heavenwards,
while the skull, in turn, beholds his upturned face.
I would say that Francis's eyes are closed
but this is guesswork, since they are occluded
wholly by the shadow of his cowl,
for which we read the larger dark he claims
beyond the local evening of his cell.
But I would say the fetish-point, the *punctum,*
is not the skull, the white cup of his hands
or the frayed hole in the elbow of his robe,
but the little batwing of his open mouth,
and its vowel, the *ah* of agony or grief
or revelation; but in this case, I would say
there is something in the care of its depiction
that proves that we arrest the saint mid-speech.
I would say something had passed between
the man and his interrogated night.
I would say his words are not his words.
I would say the skull is working him.

III

(Or to put it otherwise: consider this
pinwheel of white linen, at its heart
a hollow, in the hollow a small hole.
We cannot see or say whether the hole
passes through the cloth, or if the cloth
darkens itself – by which I mean *gives rise*
to it, the black star at its heart,
and hosts it as a mere emergent trait
of its own intricate infolded structure.
Either way, towards the framing edge
something seems to have called into question
the linen's own materiality
and the folds depicted are impossible.)

IV

Zurbarán knew well he'd guarantee
at least one fainter at the first unveiling
if he arranged the torch- or window-light
to echo what he'd painted in the frame;
and so, to those who first beheld the saint,
the light that fell on him seemed literal.

In the same way I would have you read these words
on a black moon, in a forest after midnight
a thousand miles from anywhere your plea
for hearth or water might be understood
and have you strike one match after another –
not to light these rooms, or to augment
what little light they shed upon themselves
but to see the kind of dark I laid between them.

V

We come from nothing and return to it.
It lends us out to time, and when we lie
in silent contemplation of the void
they say we feel it contemplating us.
This is wrong, but then the truth is senseless.
We are ourselves the void in contemplation.
We are its only nerve and hand and eye.
There is something vast and distant and enthroned
staring though your mind, staring and staring
like a black sun, constant, silent, radiant
with neither love nor hate nor apathy
as we have no human name for its regard.
Your thought is the bright shadow that it throws
as plays across the objects of the world.
The book in sunlight or the tree in rain
bursts at its touch into a flame of signs.
But when the mind stops and the light can still
the book falls back to its bare mystery,
and if a word then rises to our lips
we speak it on behalf of everything.

For one year after, when I lay down, the eye
looked through my mind uninterruptedly
and I knew a peace like nothing breathing should.
I was the no one that I was in the dark womb.
One night when I was lying in meditation
the I-Am-That-I-Am-Not spoke to me
in silence from its black and ashless blaze
in the voice of Michael Donaghy the poet.
It had lost his lightness and his gentleness
and took on that plain cadence he would use
when he read out from the Iliad or the Táin.

Your eye is no eye but an exit wound.
Mind has fired through you into the world
the way a hired thug might unload his gun
through the lining of his overcoat.
And even yet, the dying world maintains
its air of near-hysteric normalcy
like a state room on a doomed ship, every
table, chair and trinket nailed in place
against the rising storm of its unbeing.
If only you had known the storm was you.

Time was you could not tell us apart:
before life there was futureless event,
and as the gases cooled and inspissated
time had nothing to regret its passing
and everywhere lay lightly upon space
as daylight on the objects of the earth.
Then matter somehow wrenched itself around
to watch – or rather just in time to miss –
the infinite laws collapse, and there behold
the perfect niche that had been carved for it.
But far worse was that final inward turn
whereby you conjured up a self, a soul, a god.
But the blind have the advantage in the dark
and if they have the sense to keep to it
can better know the other eye upon them,
the other mind's regard. Do not return it –
there is nothing in its gaze you would not call
Death – but let it be your blindsight.

VII

The voice paused; and when it resumed
it had softened and I heard the grin in it.
Donno, I can't keep this bullshit up.
I left this message planted in your head
like a letter in a book you wouldn't find
till I was long gone. Besides, the monkey
ate my suicide note. You should've read it.
It was hilarious. Look – do this for me:
just plot your course between the Orphic oak
and fuck 'em if they can't take a joke
and stick to it. Avoid the fancy lies
by which you would betray me worse than looking
the jerk that you're obliged to now and then.
A shame unfelt is no shame, so a man's
can't outlive him. Not that I ever cared.
Remember that drunk night when we discovered
those giant Xeroxed barcodes on the floor
and I hopscotched up and down them, while the artist
watched in ashen disbelief? My later plans
to write a book called The Compleat Idiot?
But for all that I was always first to jump
I never got it with the gravity.
I loved the living but I hated life.
I got sick of trying to make them all forgive me
when no one found a thing to be forgiven,
sick of my knee-jerk apologies
to every lampstand that I blundered into.
Just remember these three things for me:
always take a spoon – it might rain soup;
it's as strange to be here once as to return;
and there's nothing at all between the snow and the roses.
Don't let them misread those poems of mine

as the jeux d'esprit *I had to dress them as*
to get them past myself. And don't let pass
talk of my saintliness or those attempts
to praise my average musicianship
beyond its own ambitions. Music for dancers.
All I wanted was to keep the drum
so tight it was lost under their feet.
The downbeat I'd invisibly increased.
My silent augmentation of the One ...
The cup I'd filled, then filled above the brim!
But what kind of ape ends up believing
the rushlight of his little human art
more true than the sun upon his back?
I knew the game was up for me the day
I stood before my father's corpse and thought
If I can't get a poem out of this *...*
Did you think any differently with mine?
Paterson: we framed ourselves.

He went on with his speech, but soon the eye
had turned on him once more, and I'd no wish
to hear him take that tone with me again.
I closed my mouth and put out its dark light.
I crossed the room and closed the window-sash.
I put down Michael's skull and held my own.

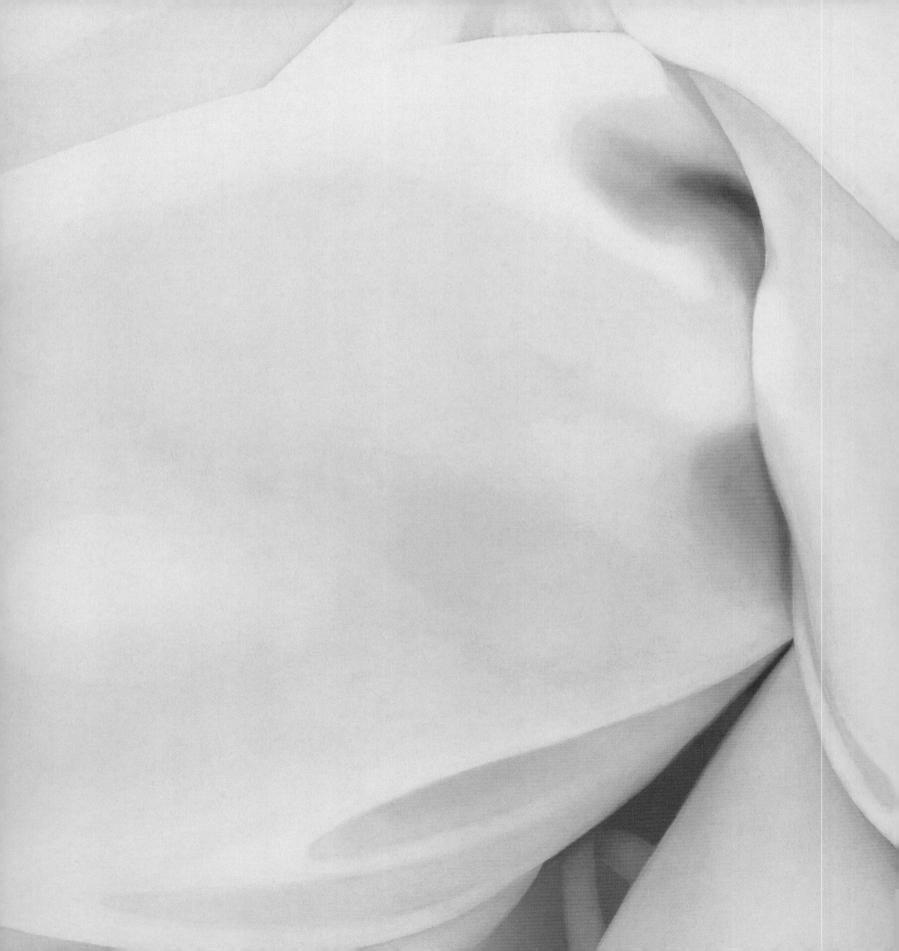

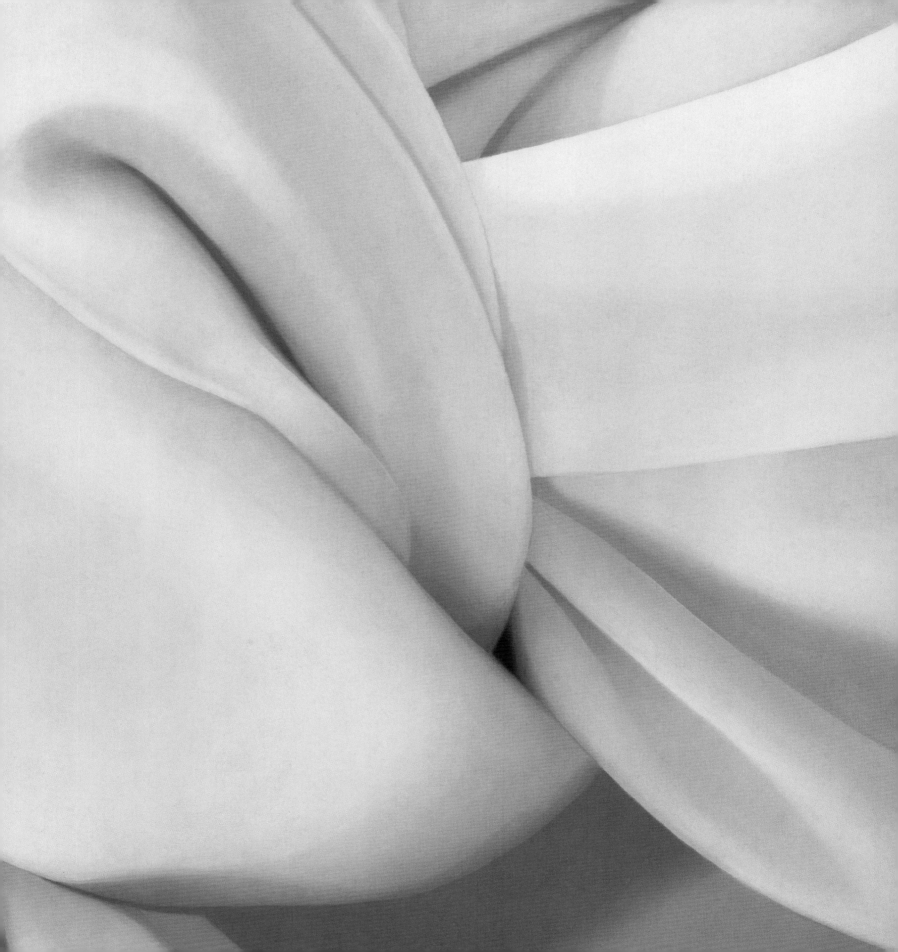

1 PULSE

2006 · oil on canvas · 304.8 x 213.4 cm

Private collection

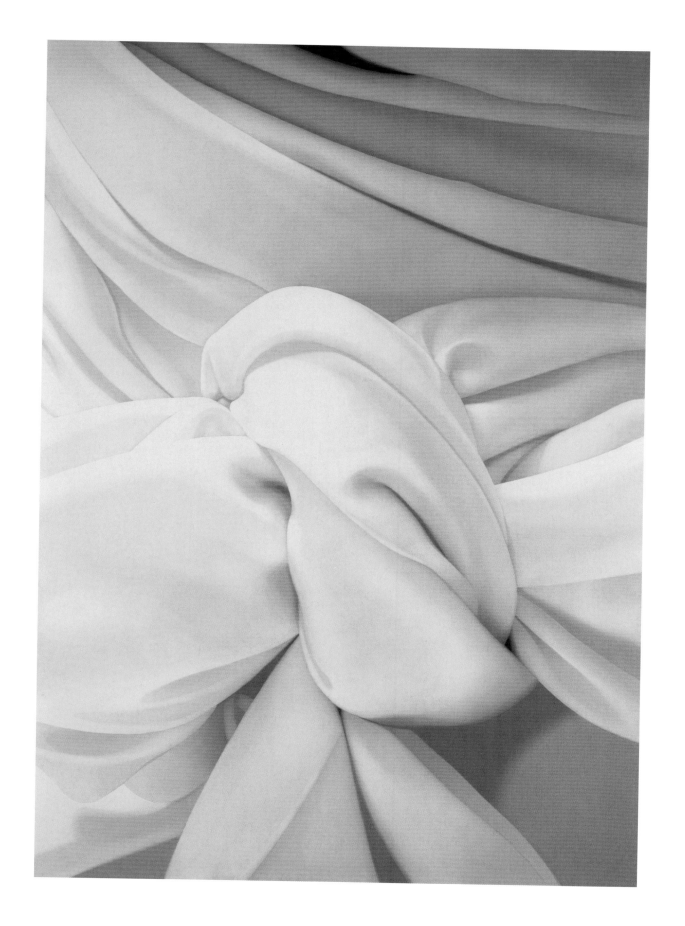

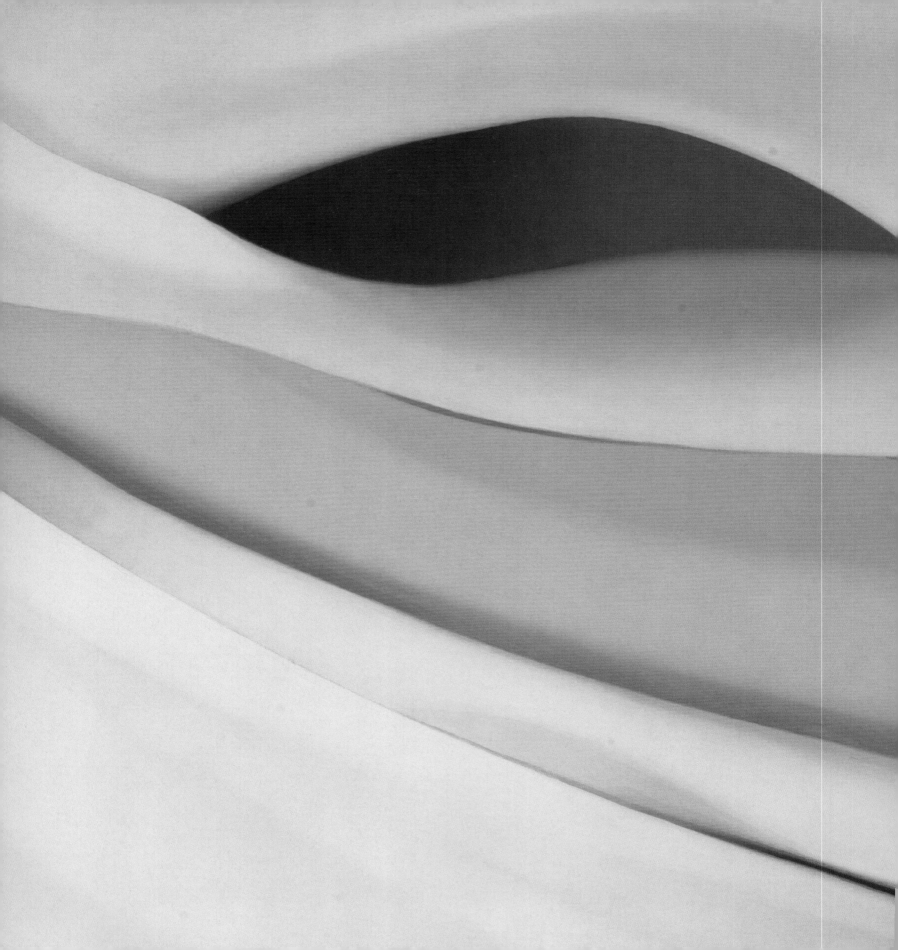

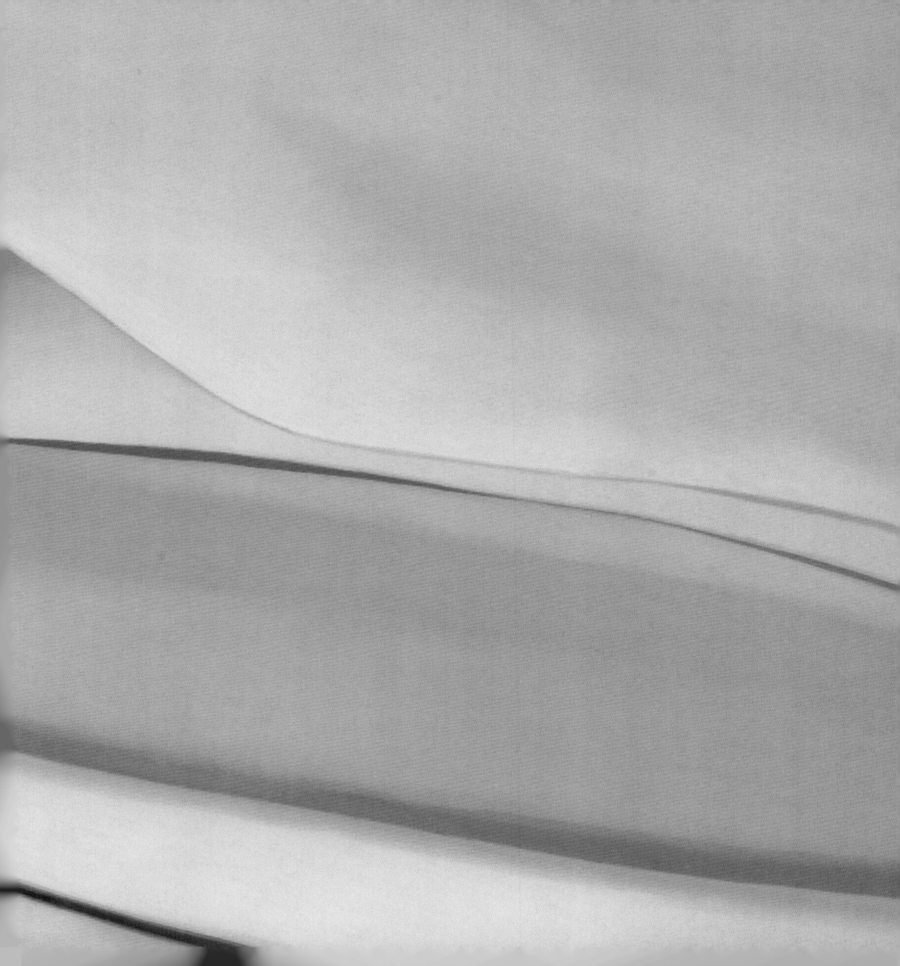

2 ECHO

2006 · oil on canvas, 304.8 × 213.4 cm

The HBOS Art Collection

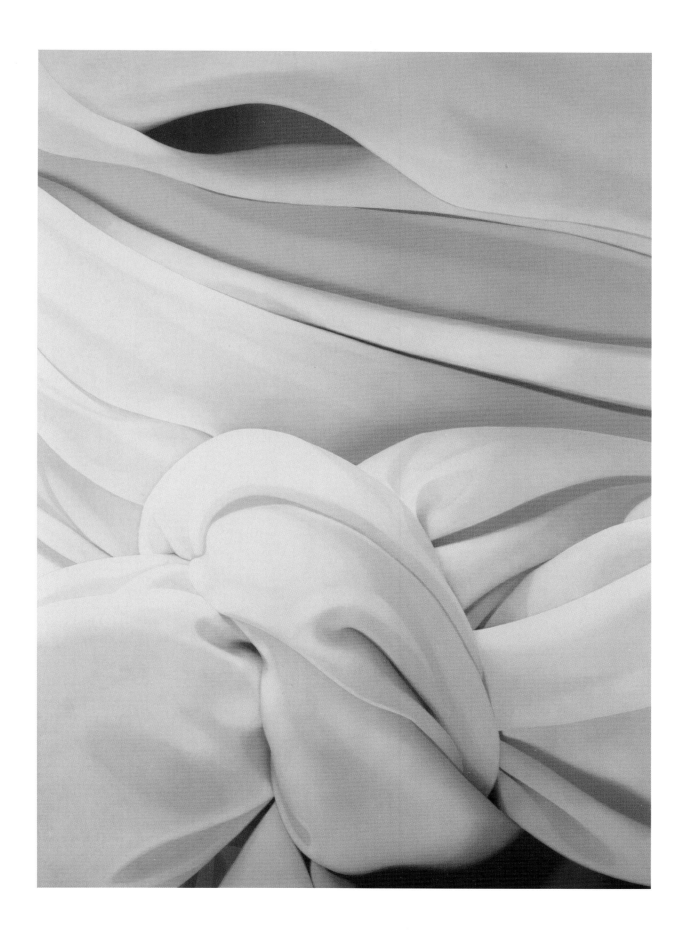

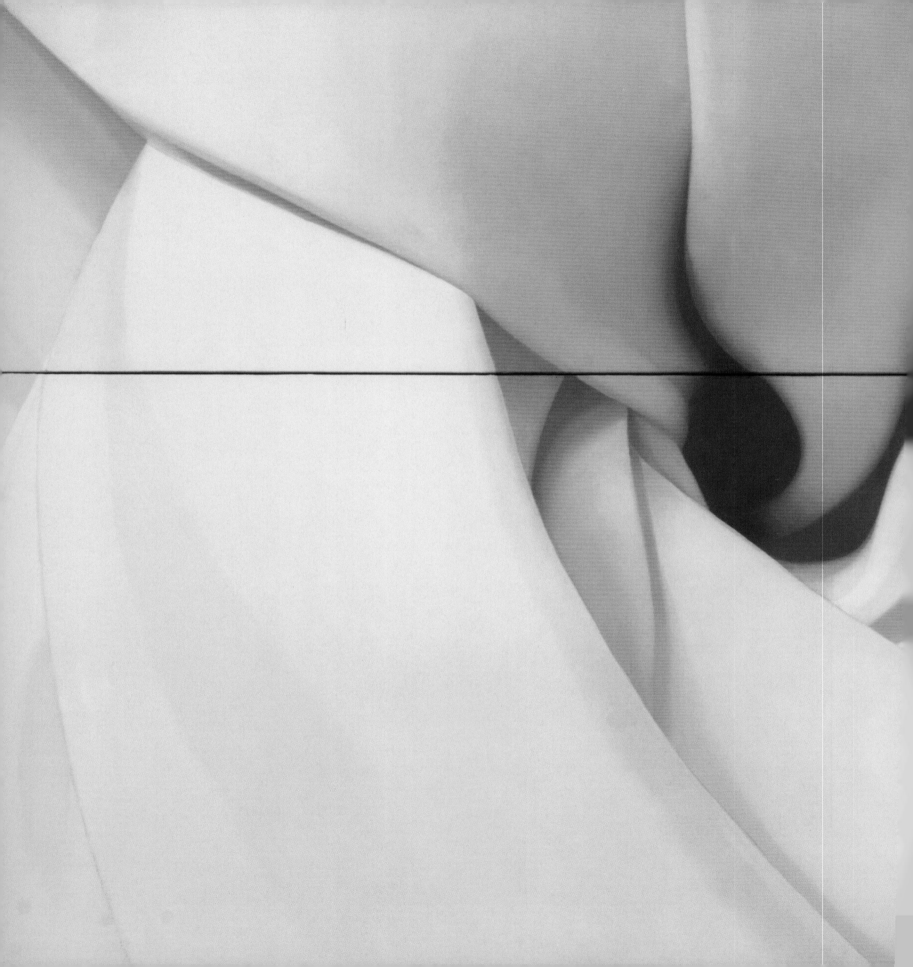

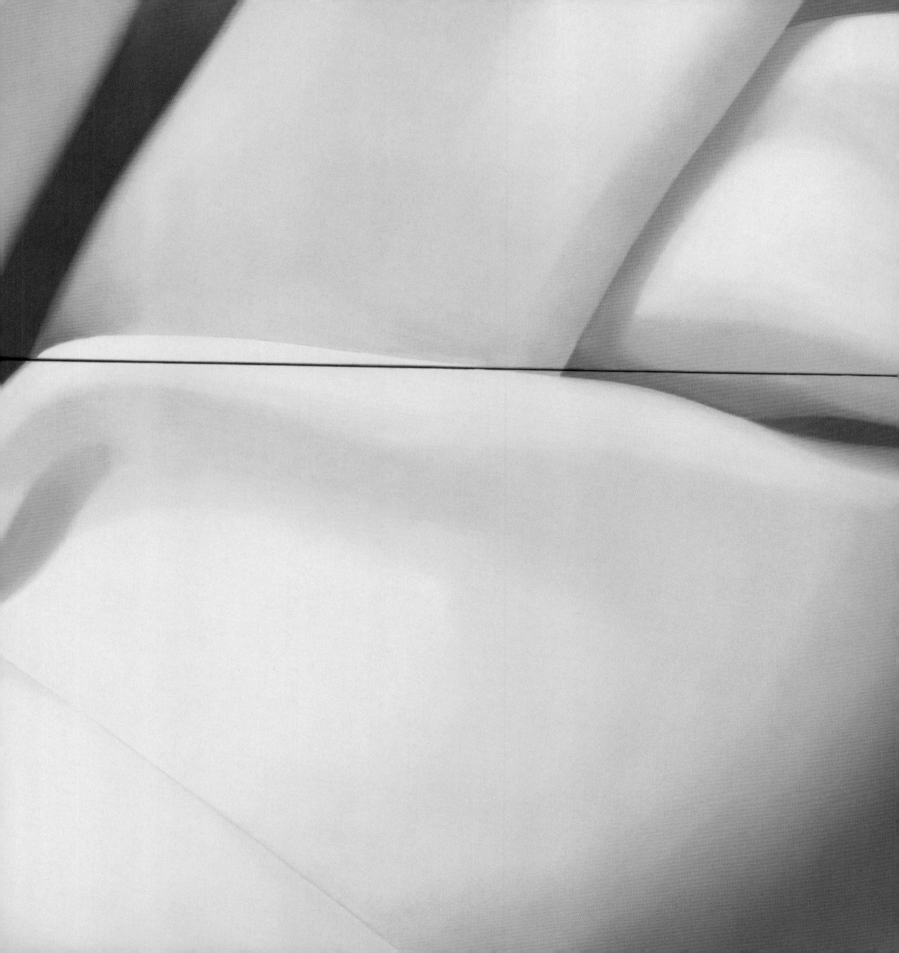

3 HOST

2006–7 · oil on canvas · 609.6 x 304.8 cm (two panels, 213.4 x 304.8 cm)

Courtesy Alison Watt / Ingleby Gallery, Edinburgh

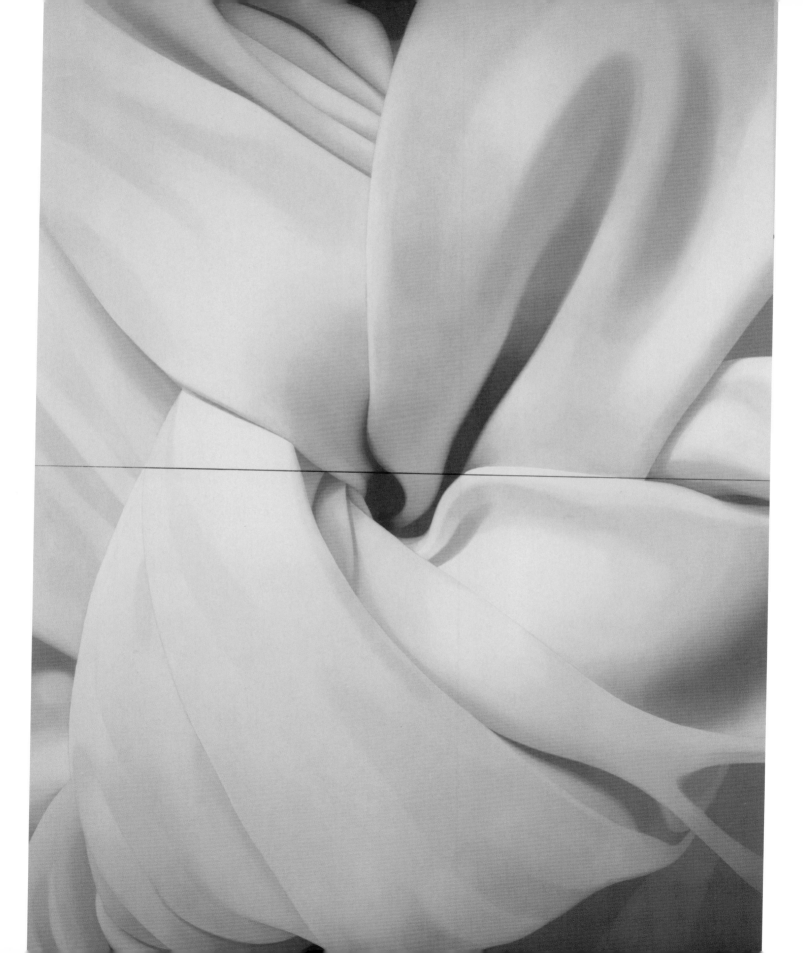

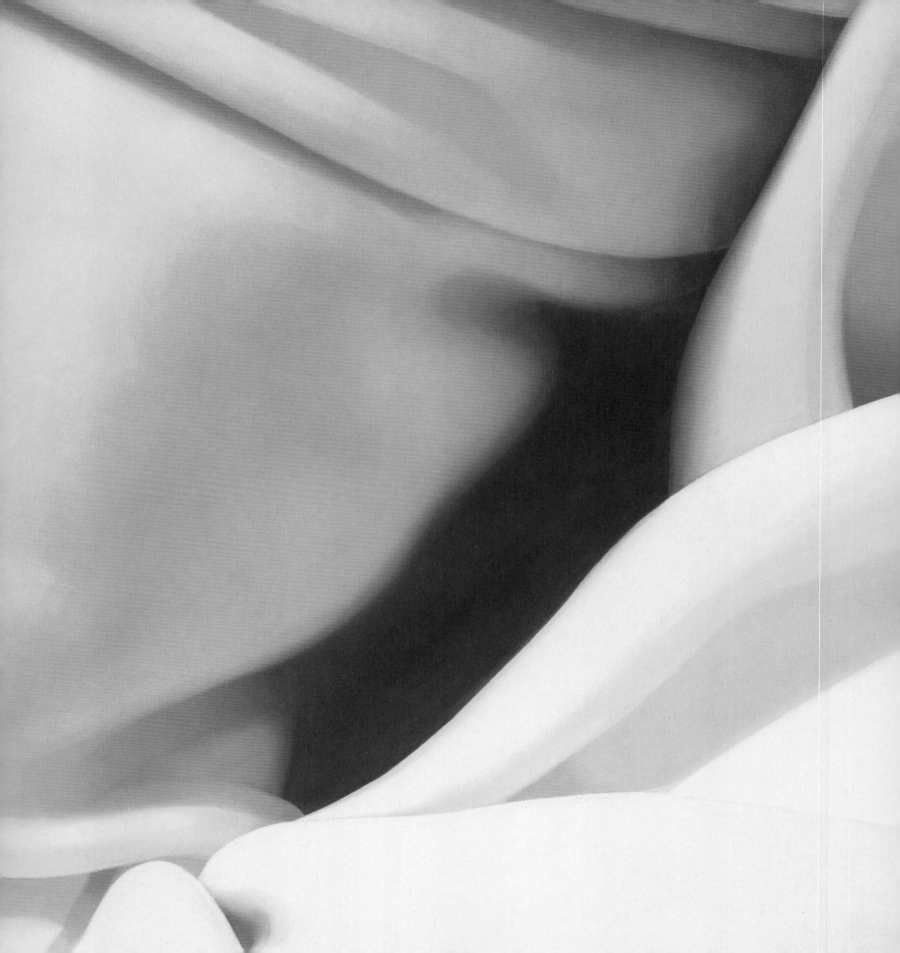

4 PHANTOM

2007 · oil on canvas · 213.4 x 335.3 cm

Courtesy Alison Watt / Ingleby Gallery, Edinburgh

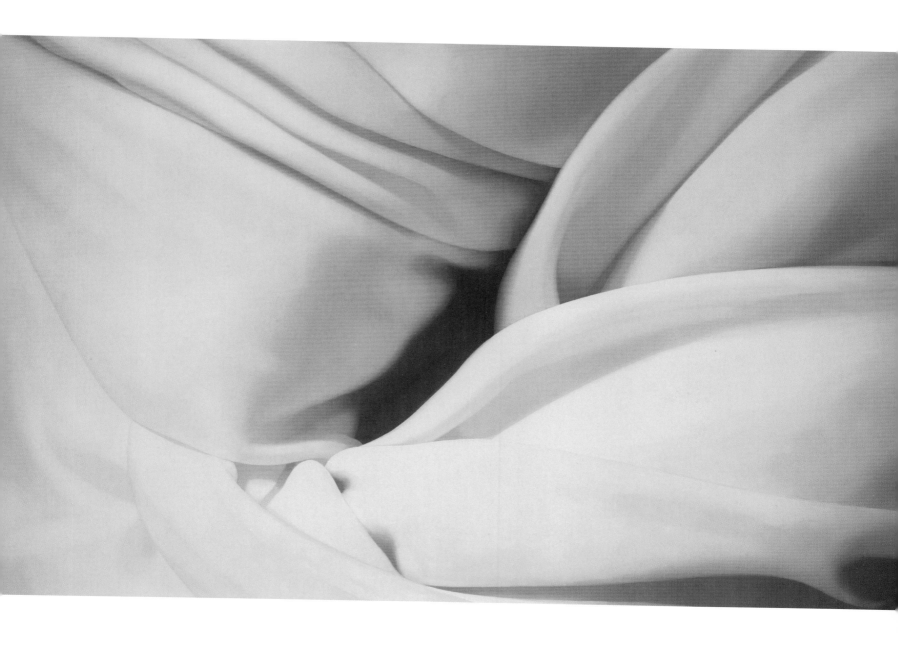

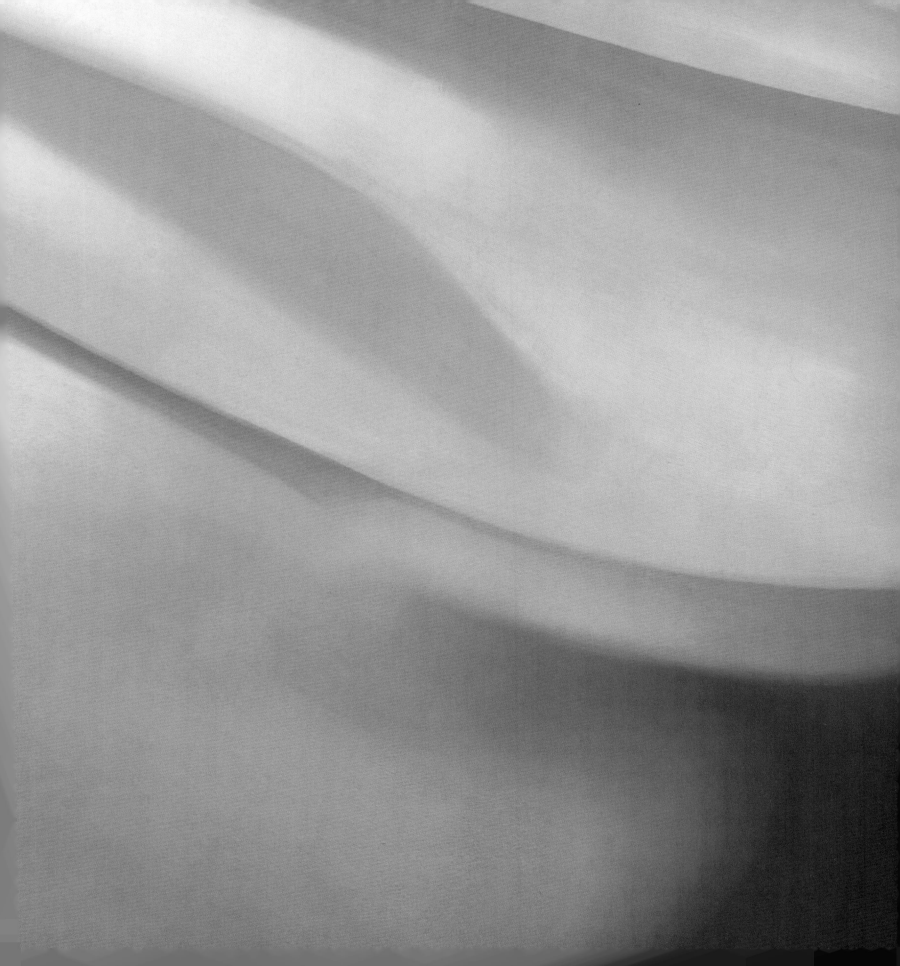

5 VOWEL

2007 · oil on canvas · 274.3 x 213.4 cm

Courtesy Alison Watt / Ingleby Gallery, Edinburgh

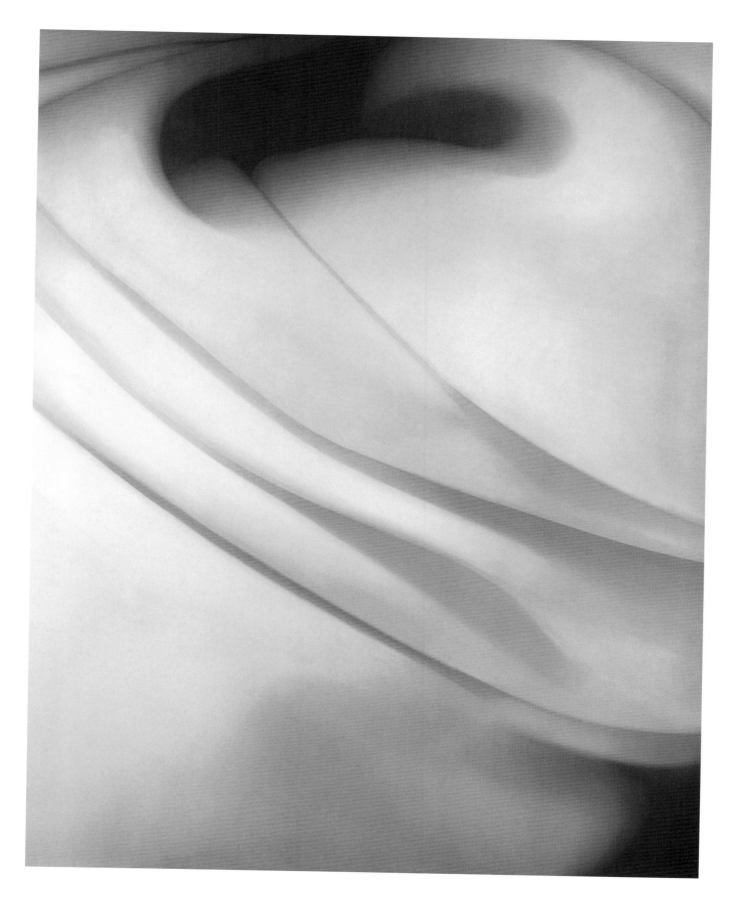

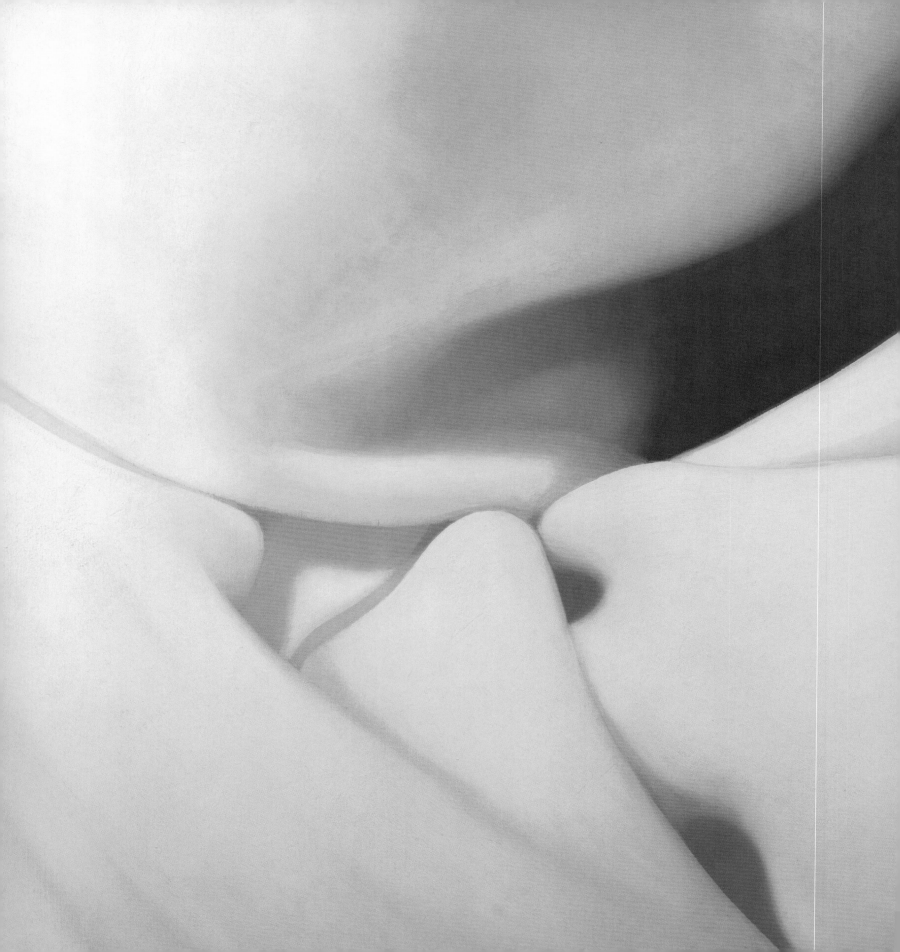

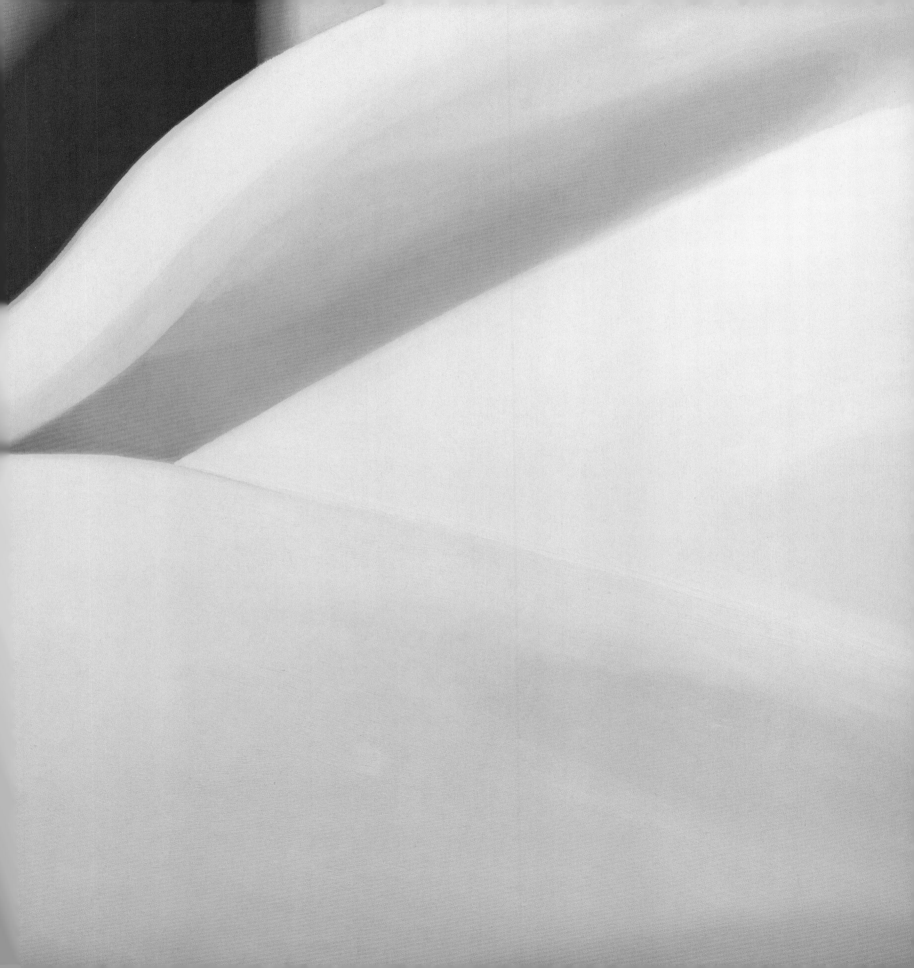

6 ROOT

2007 · oil on canvas · 213.4 x 213.4 cm

The British Council Collection

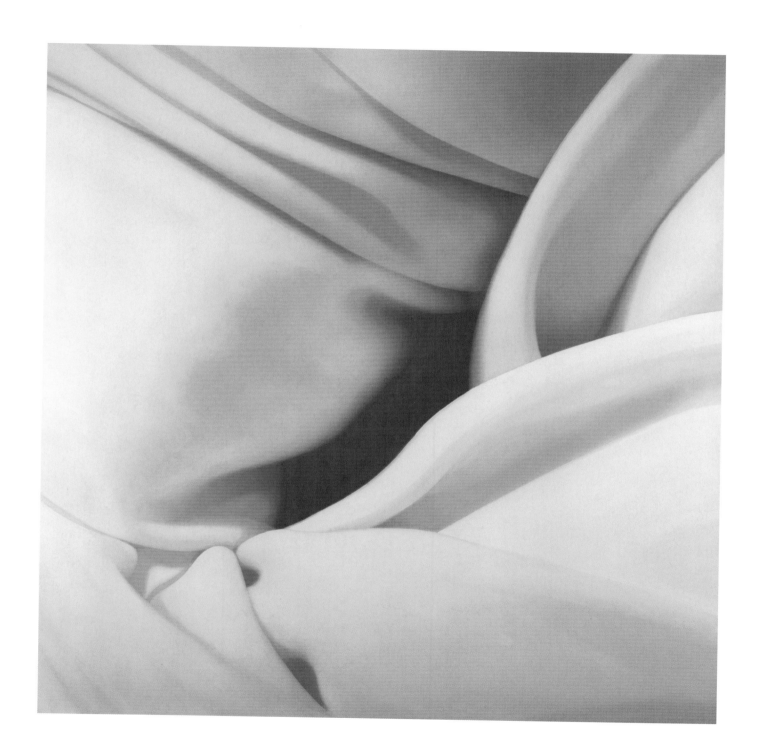

7 EYE

2007–8 · oil on canvas · 40.6 x 40.6 cm

Courtesy Alison Watt / Ingleby Gallery, Edinburgh

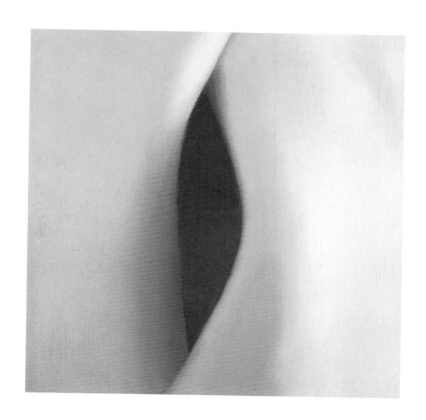

A young Alison Watt outside the National Gallery, early 1970s
Collection of the artist

BIOGRAPHY

1983–7

Studied at Glasgow School of Art

1987–8

Glasgow School of Art Postgraduate Studies

Alison Watt lives and works in Edinburgh and London

RECENT SOLO EXHIBITIONS

2007

Dark Light, Ingleby Gallery, Edinburgh

2004

Alison Watt, Ingleby Gallery, Edinburgh

Still, Memorial Chapel, Old St Paul's Church, Edinburgh

2002

New Paintings, Dulwich Picture Gallery, London

2000

Shift, Scottish National Gallery of Modern Art, Edinburgh

1998

Fold, Aberdeen Art Gallery and Museum; Leeds Metropolitan University Gallery

1997

Flowers East, London

The Fruitmarket Gallery, Edinburgh

SELECTED AWARDS

2006–8

Rootstein Hopkins Associate Artist, The National Gallery, London

2005

ACE Award for *Still*, her installation at Old St Paul's Church, Edinburgh

Glenfiddich Artist in Residence

2004

Winner of Creative Scotland Award

2003

Shortlisted for Jerwood Painting Prize

1996

Scottish Arts Council: Individual Artists Award

1993

City of Glasgow Lord Provost Prize

1987

Winner of the John Player Portrait Award, National Portrait Gallery, London

Armour Prize for Still Life Painting, Glasgow School of Art

1986

British Institution Fund, First Prize for Painting, Royal Academy, London

SELECTED COLLECTIONS

Aberdeen Art Gallery

The Boswell Collection

The British Council

British Broadcasting Corporation

Christie's Corporate Art Collection

Deutsche Bank

Ferens Art Gallery, Hull

Robert Fleming Holdings Ltd

The Freud Museum, London

Glasgow Art Gallery & Museum

The HBOS Art Collection

McMaster University Art Gallery, Ontario

The National Portrait Gallery, London

National Westminster Bank, London

Scottish National Gallery of Modern Art

The Scottish Parliament

Southampton Art Gallery

Alison Watt's studio, The National Gallery, London
Film still, 2006

ACKNOWLEDGEMENTS

My thanks are due to the following: Kathy Adler; Xavier Bray; Jon Campbell and the National Gallery Visitor Services and Security team; Dawson Carr; Robert Dalrymple; Colin Harvey; Richard and Florence Ingleby; Thomas Kibling; Marcus Latham; Ruaridh Nicoll; Chris Oberon; Don Paterson; Lee Riley; Mark Slattery and the National Gallery Art Handling Department; Charles Saumarez Smith; James and Nancy Watt; Colin Wiggins; Martin Wyld and the National Gallery Conservation Department; Claire Young; Jane Hyne, Penny Le Tissier and the catalogue production team. My thanks also to Bank of Scotland Private Banking and the Rootstein Hopkins Foundation.
Alison Watt

This publication has been generously sponsored
by Bank of Scotland Private Banking

LOOK AT THINGS DIFFERENTLY
✳ BANK OF SCOTLAND

This book was published to accompany the exhibition
Alison Watt: Phantom held at the National Gallery, London,
from 12 March to 22 June 2008

First published in Great Britain in 2008 by
National Gallery Company Limited
St Vincent House · 30 Orange Street · London WC2H 7HH
www.nationalgallery.co.uk

ISBN: 978 1 85709 412 1
525530

Every purchase supports The National Gallery

British Library Cataloguing-in-Publication Data
A catalogue record is available from the British Library
Library of Congress Control Number: 2007935054

Publisher Louise Rice
Project Editor Claire Young
Picture Researcher Suzanne Bosman
Production Jane Hyne and Penny Le Tissier

Designed and typeset in Magma by Dalrymple
Printed in Belgium by Die Keure

Jacket: detail from *Host*, see page 52
Endpapers: detail from *Pulse*, see page 44

Unless otherwise stated, all works are by Alison Watt.
All measurements give height before width